Carol Lerner

A BIBLICAL GARDEN

Translations from the Hebrew Bible
by Ralph Lerner

William Morrow and Company
New York 1982

Printed in the United States of America.
1 2 3 4 5 6 7 8 9 10

Library of Congress Cataloging in Publication Data

Lerner, Carol.
 A Biblical garden.

 Summary: Descriptions and pictures of twenty plants mentioned in the Old Testament, including fig, lentil, olive, papyrus, and pomegranate.
1. Plants in the Bible. [1. Plants in the Bible] I. Title. BS665.L46 220.9′1 81-16886
 ISBN 0-688-01071-7 AACR2

CONTENTS

Exotic Strangers 5

Fig 8

Lentil 10

Olive 12

Papyrus 14

Pomegranate 16

Barley 18

Gourd 20

Coriander 22

Myrtle 24

Flax 26

Almond 28

Cedar of Lebanon 30

Castor Bean 32

Cypress 34

Grape Vine 36

Sycomore 38

Caper 40

Date Palm 42

Oil Tree 44

Poplar 46

EXOTIC STRANGERS

The people of the Bible lived and worked close to the land. The crops of field and orchard, and those wild plants scattered through the deserts and forests, were familiar features of their everyday lives. The appearance of those plants, their habits of growth, the routines of their cultivation and harvest were all part of the common knowledge of the ancient Israelites.

Plant names appear throughout the books of the Bible. Often they are used as symbols or to make a comparison. These many references give vivid detail to the tales, and they certainly made the teachings more immediate and clear to the Hebrew people.

Today, reading the Bible in translation in a distant country, we barely can imagine that world of herdsmen and simple farmers. The plants that surrounded them are equally remote and strange. We find the references to them sometimes puzzling, often meaningless.

But the same plant species still live in modern times, little changed during the years that separate us from the events of the Bible. This book introduces a handful of these exotic strangers and tries to give a sense of the way they look and how they grow.

All of the examples are taken from verses in the Jewish Bible, or Old Testament, and each of the plant portraits is accompanied by a quotation in which it appears. The Hebrew word used for the plant is given, along with the scientific name. When there are two citations for a verse, the first refers to the Hebrew Bible and the second to the King James version.

For centuries, readers have been curious about all aspects of natural history reported in the biblical writings; Bible plant life has received its share of this attention. Many books and articles were written, trying to identify the plants, describing them, and arguing over doubtful references.

The identification of some of the plant names is clear and unambiguous, especially those of cultivated plants—olives, wheat, grapes, leeks, and the like. About half of the examples here fall into this agricultural group.

But when the reference is to the wild plants of the land, identification may be a puzzle. Some words are used only once or a few times in the Bible and obviously refer to specific plants, but the verses do not give enough clues to make certain which ones are meant.

Sometimes the Hebrew word is so much like a plant name in a closely related language that the similarity gives a hint—or even solves the question. The plant life of Bible lands in modern times gives more evidence, but this information has to be used carefully. Much of the evidence of past millennia has since been destroyed, and today's landscape includes many species introduced in more recent times. Because of these uncertainties, translators often have disagreed about which words to use for some of the plant names.

Two groups of plants have brought special grief to botanists and translators trying to make firm identifications. One is the conifers, or cone-bearing trees and shrubs—the pines, firs, etc. Some were very large trees, growing in great stands in the native forests of the land, but the words used for them are often inconsistent and confusing. The outstanding exception is the cedar of Lebanon. Though it grew outside of the present land of Israel, the tree and its qualities were well known, and the references to it are clear.

The words usually translated as "roses" and "lilies" (*chabatseleth, shoshan*) are another source of confusion. Any number of other handsome wild flowers of the region—anemone, tulip, iris, and so on—may also have been meant by the Hebrew. But the best-informed scholars have concluded that we cannot know what particular flowers, if any, were intended and that the words should be understood to refer to any showy or brightly colored wild flowers.

Some of the other plant words seem to refer merely to a detail of plant structure or to a whole plant group, rather than to any individual kind of plant. Examples are the words usually translated as "thorn" (*qots*) and as "rush" or "reed" (*agmon*). They may have been the names of particular species, but today there is no way of knowing which thorny plant or which reed was meant.

In spite of all these pitfalls, there are many species that we can regard as being plants of the Bible—though not always with the same degree of confidence. Such plants are more numerous than could be included in this small book, and choices among them had to be made.

All of those included actually grew in the lands of the Bible in biblical times. They were familiar to the Hebrews *as plants*. Species that were known only as imported plant products from distant lands have been left out. Cinnamon and ebony are two examples.

The plants included are accepted as proper identifications by most scholars of the subject. Not all of them are certainties; some are just the most likely candidates, on the grounds of geography or language or because they fit the context. If there is doubt, it is mentioned in the description that goes with each plant.

Of course, no book of pictures can substitute for the direct experience of the living plants. But it can contribute to an understanding of the biblical verses and perhaps give a sharper sense of that distant world.

FIG

te'aynah
Ficus carica

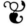 *Then the eyes of the two of them were opened,*
and they realized that they were naked;
and they sewed together fig leaves
and made themselves loincloths.
GENESIS 3:7

The fig is the first plant to be mentioned by name in the Bible. The many references to the fig tree throughout the Scriptures show its importance in biblical life. Fresh or dried, figs were part of the daily diet of the people.

Like many of these ancient agricultural plants, the fig was cultivated so early in human history that its origins are not known. It is a small tree, ten to twenty feet high. The year's first figs begin to grow before the leaves unfold, but they are small and hard and not good to eat. A second crop ripens over the summer and provides the edible figs.

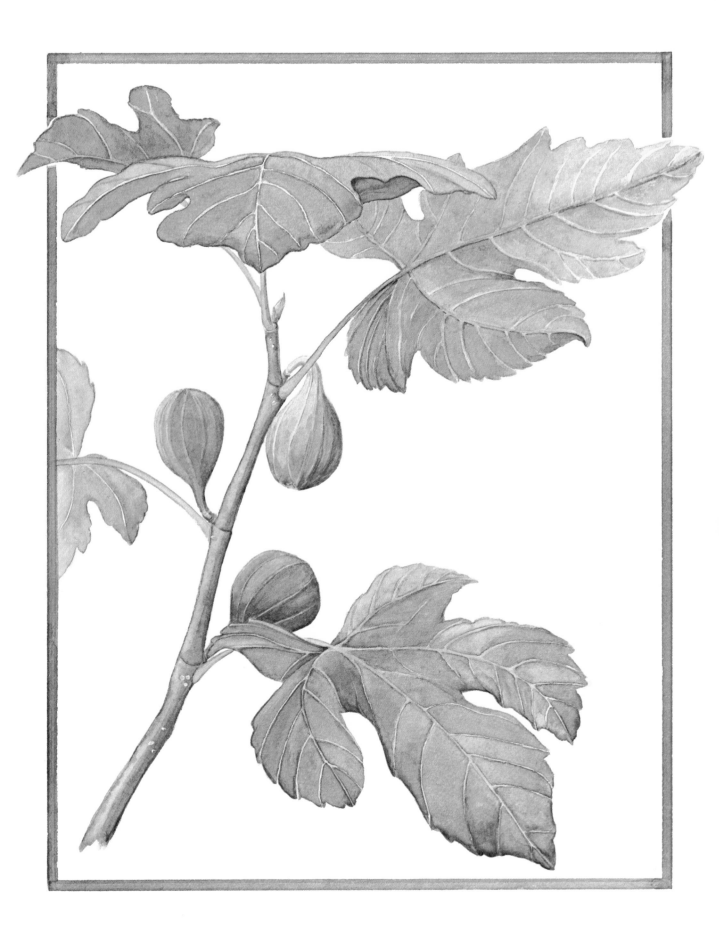

LENTIL
'adashim
Lens esculenta

 And Esau said, "I am at the point of death;
 of what use, then, is my birthright to me?"
 But Jacob said, "Not until you swear to me."
 So he swore to him,
 and sold his birthright to Jacob.
 Then Jacob gave Esau bread and lentil stew....
 GENESIS 25:32-34

The lentil—along with wheat, barley, and peas—is one of the very oldest plants to be cultivated for food. Its white flowers develop into small pods, each containing one or two lentil seeds. These seeds were eaten in a stew or used to make a heavy bread.

Lentils can grow in inferior soil and were an inexpensive food, popular with poor people. Esau traded his birthright for a very commonplace meal.

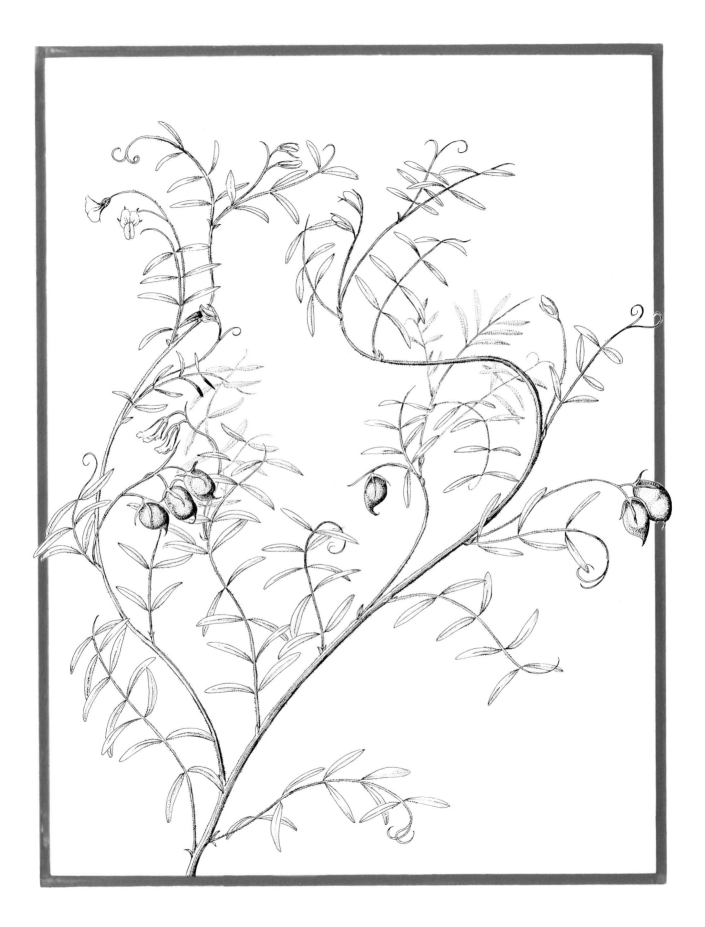

OLIVE

zayit

Olea europaea

❧ *And the dove came back to him toward evening,*
and in its beak was a fresh-plucked olive leaf!
Then Noah knew that the water on the earth
had gone down still further.
GENESIS 8:11

E ver since that dove carried the olive leaf to Noah, this tree has been a symbol of peace. The olive was perhaps the most important tree in the lives of biblical people. The fruits and their oil were used for food, and the oil was a fuel to burn in lamps. Olive oil was usually the substance being used whenever the Bible speaks of "ointments" or "anointing" the body.

The olive is an evergreen tree that often lives for hundreds of years. Wild olive trees, with small fruits, grow in many places along the shores of the Mediterranean and may be the ancestors of the cultivated olive tree.

PAPYRUS

gome'
Cyperus papyrus

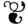 *When she could hide him no longer,*
she got a papyrus basket for him
and coated it with clay and pitch....
EXODUS 2:3

The word *gome'* has often been translated as "bulrush," but most scholars agree that this basket was made from papyrus plants. In Bible times, papyrus grew in thick stands along the shores of the Nile, where Moses floated to safety.

The plants have a straight triangular stem (culm), one to three inches thick at the bottom and growing ten to fifteen feet high. A tuft of drooping stalks grows from the top of the stem, and each stalk carries clusters of tiny flowers. The tall culms were used for making paper as well as for weaving mats and small boats.

POMEGRANATE

rimmon
Punica granatum

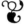 *On its hem make pomegranates*
of violet, purple, and scarlet yarn
all around its hem,
with golden bells between them
the whole way round.
EXODUS 28:33

Wandering in the desert, the Jews were encouraged by antici-
pation of the promised land. Pomegranates, they were told,
were among the fruits of this good land that awaited them (Deuteron-
omy 8:7-10).

The plant usually grows as a small tree and has long been
cultivated in warm climates for its fruits. These fruits are the size of an
orange with a thin, dry rind. Inside are many red seeds, each sur-
rounded by a juicy pulp. The form of the plant decorated the priestly
robes, and sculptured pomegranates appeared on the pillars of the
first Temple (I Kings 7:18, 20).

16

BARLEY

se'orah
Hordeum vulgare

ℰ *The flax and barley were ruined,*
for the barley was in the ear
and the flax was in the boll;
but the wheat and emmer were not ruined,
for they ripen late.
EXODUS 9:31-32

Barley and wheat together were the basic food grains for the people of the Bible. Barley may have been the first cereal to be cultivated for food. Since it can be grown in poorer soils and where there is not enough rainfall to raise wheat, it was the cheaper grain, eaten by the poor and fed to horses and cattle.

Barley ripens and is harvested several weeks before wheat. The hailstorm in Exodus came after the heads of grain (ears) had already developed on the barley and the seed capsules (bolls) on the flax. The wheat plants were still so young that the grains had not yet formed. The plant known as emmer is another kind of wheat.

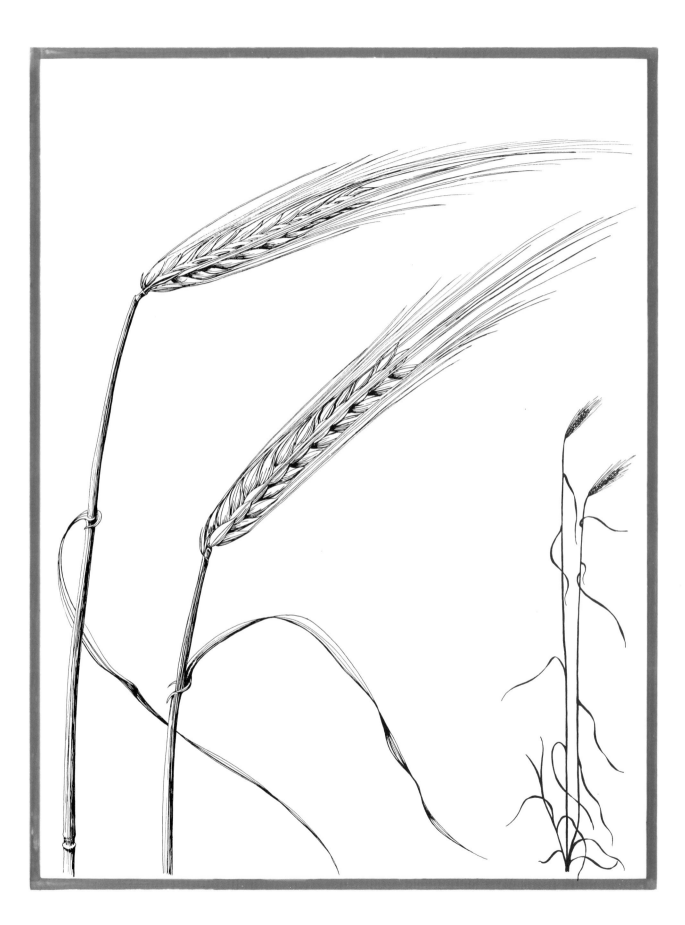

GOURD

paqqu'oth
Citrullus colocynthis

❧ *...and he found a wild vine and picked from it*
as many wild gourds as his garment would hold.
Then he came back and sliced them into the pot of stew,
not knowing what they were.
Then they served it for the men to eat.
While still eating of the stew, they cried out and said,
"O man of God, there is death in the pot";
and they could not eat it.
II KINGS 4:39-40

The poisonous plant that went into the stew was probably the colocynth. It belongs to the same plant family as cucumbers and melons, and its large fruits (up to four inches in diameter) look as if they would be good to eat. Small amounts of the bitter pulp are dried and taken as a medicine. It is a very strong laxative and would be poisonous if eaten in large amounts as a food.

The colocynth sprawls on the ground or attaches itself to fences and bushes by its small tendrils. It is probably the plant called "vine of Sodom" in Deuteronomy 32:32.

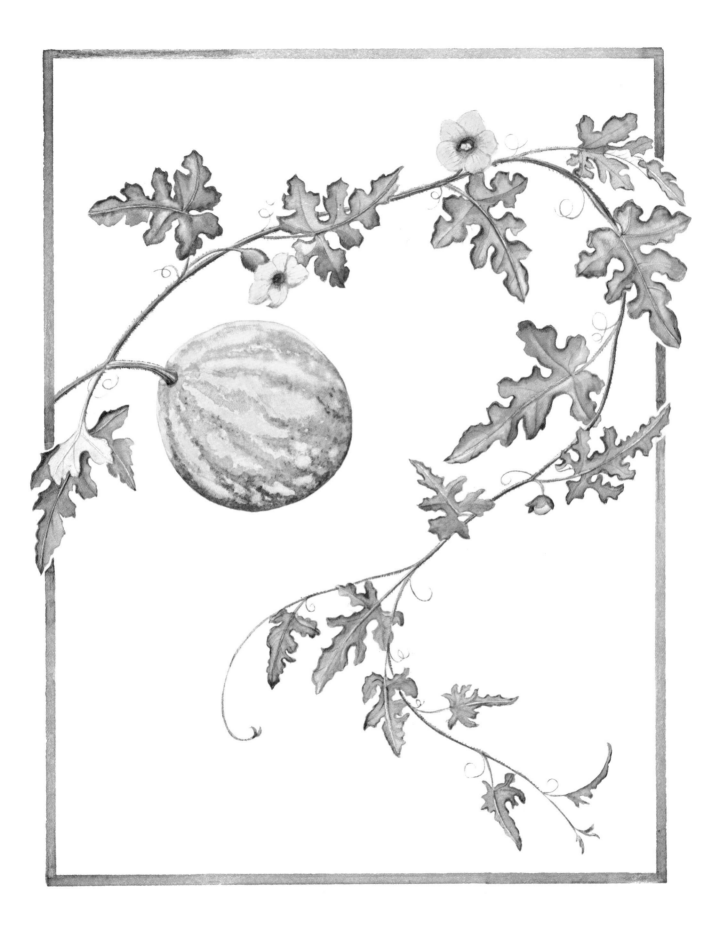

CORIANDER

gad
Coriandrum sativum

 And the house of Israel named it "manna";
it was like coriander seed, white,
and its taste was like wafers made with honey.
EXODUS 16:31

W andering through the desert after the escape from Egypt, the children of Israel grew desperate with hunger. The Bible tells how their need was met: each morning manna appeared scattered over the earth, and the Jews gathered it to eat as a substitute for bread. Coriander is mentioned only twice in the Bible, both times to describe the appearance of manna, comparing it to the coriander seeds. They are small and round and grow in clusters at the tops of many small stalks.

The plant was cultivated in Bible times and was familiar to the Hebrew people. Its seeds and leaves were used to flavor food and for medicine.

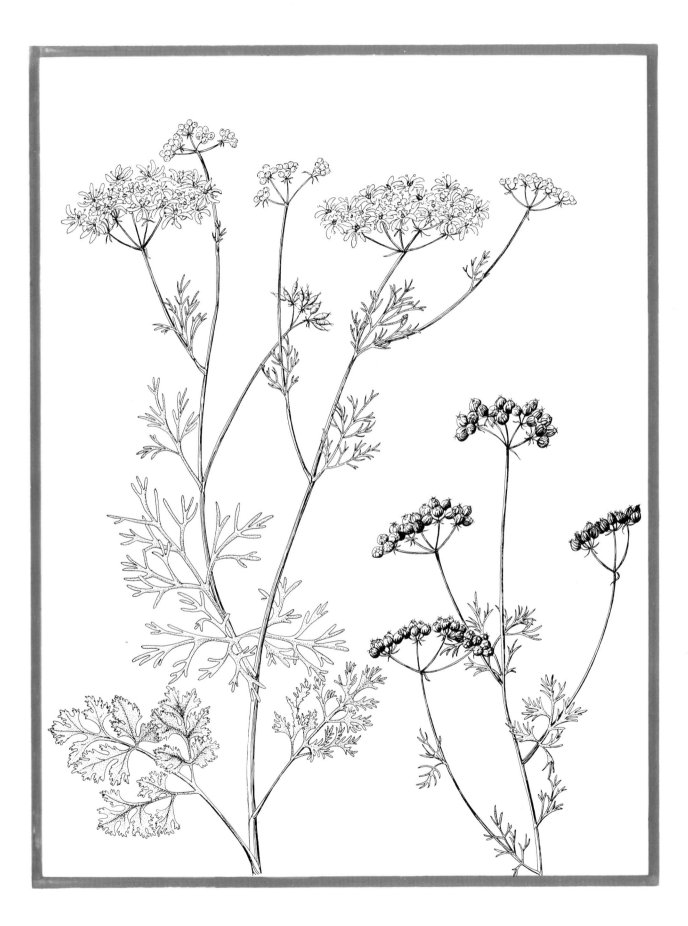

MYRTLE

hadas
Myrtus communis

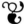 *In place of the thornbush,*
a juniper shall come up;
in place of the nettle, a myrtle.
It shall be a testimony to the Lord,
an everlasting sign that shall not perish.
ISAIAH 55:13

The myrtle is native to Israel and other Mediterranean countries. Usually it is a bushy evergreen shrub, with smooth leaves growing thickly along the twigs. All parts of the plant—leaves, the white blossoms, the blue-black berries—contain a fragrant oil.

For the Jews, it is a symbol of divine generosity, of peace and justice. Branches of myrtle are used to celebrate the Feast of Tabernacles.

FLAX

pishtah
Linum usitatissimum

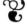 *But she had taken them up to the roof
and hidden them among the stalks of flax,
which she had set out in rows on the roof.*
JOSHUA 2:6

Flax is the oldest fiber plant to be cultivated and was grown in Bible lands long before cotton was introduced there. It grows two to three feet tall with blue or white flowers. The stalks on the roof were being dried in the sun after harvest. After drying, the silky fibers are separated from the woody parts of the stem and then spun into linen threads.

Today flax is raised in many parts of the world, including North and South America. It often can be found in the United States in waste places, growing as a weed.

26

ALMOND

shaqed
Amygdalus communis

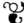 *The word of the Lord came to me, saying,*
"What do you see, Jeremiah?"
And I said, "I see a branch of an almond tree."
The Lord said to me, "You have seen well,
for I am watchful to carry out My word."
JEREMIAH 1:11-12

The almond blooms very early and is a symbol of the spring to come. In Israel, the pink or white blossoms burst open in February and March, but generally the leaves develop only after the tree has flowered. Almond trees grow there in the wild and also in orchards. The nut we eat is the seed of the fruit. It develops inside a velvety covering, enclosed by a hard shell.

The Hebrew word for almond also means "to be watchful" or "to be wakeful," and the passage from Jeremiah plays on this second meaning of the word.

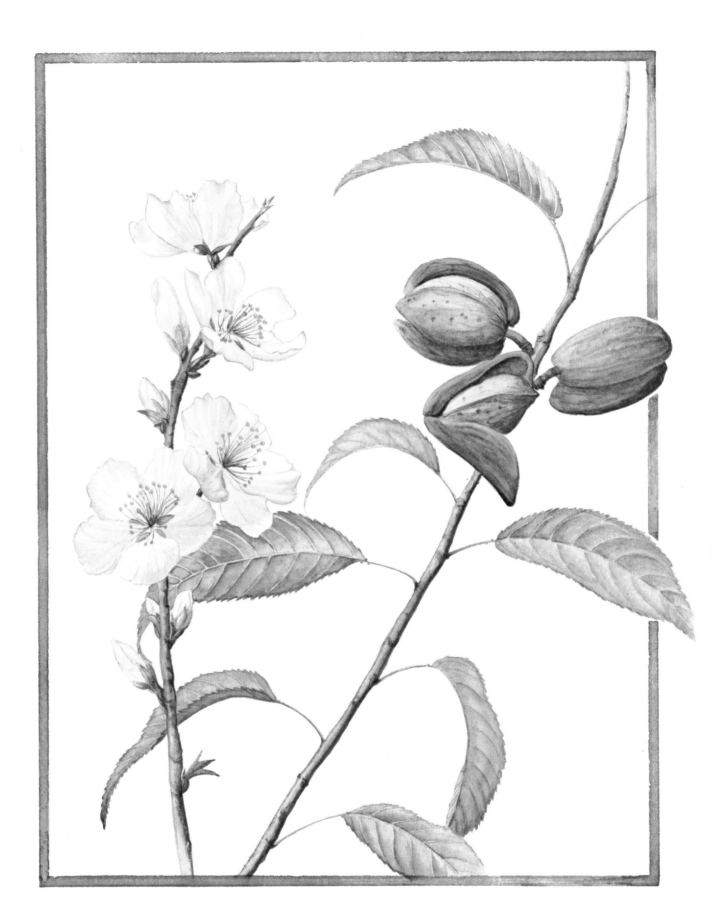

CEDAR OF LEBANON

erez
Cedrus lebani

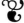 *And he spoke of trees,*
from the cedar of Lebanon down to the marjoram
that grows out of the wall....
I KINGS 5:13 (4:33)

Cedars of Lebanon are certainly the most famous of all the trees of the forest named in the Bible. They were the largest tree known to the Hebrew people and became a symbol of grandeur and power. According to this verse then, Solomon's knowledge of plants ranged from the most grand to the most humble.

These trees grow to be a hundred feet tall or more, with huge trunks and wide-spreading branches. Some specimens in Lebanon are over a thousand years old. Large quantities of durable cedar lumber were imported from Lebanon by the Jewish kings to build temples and palaces.

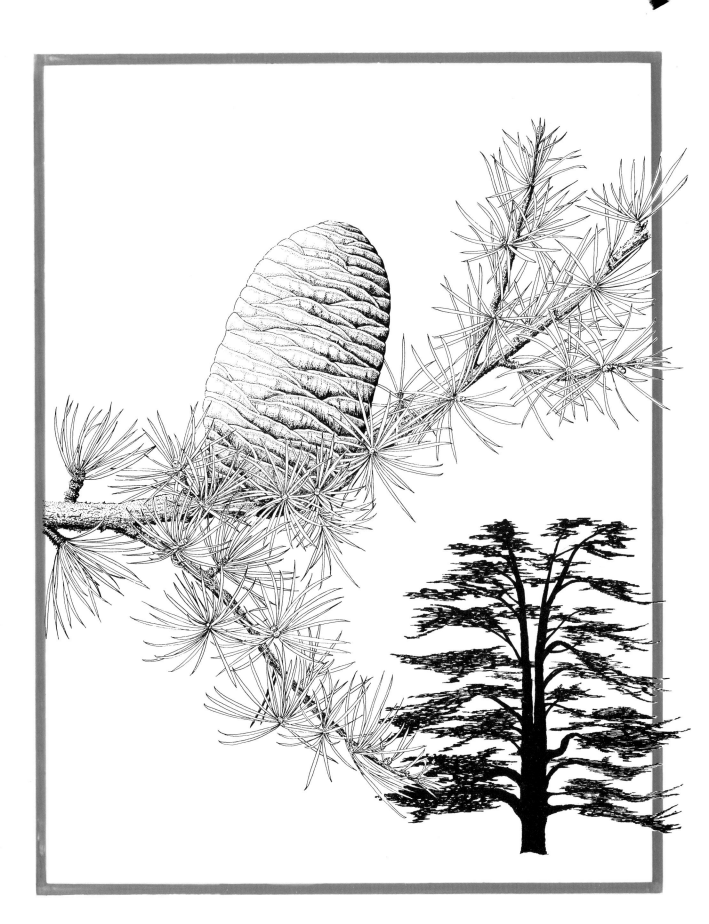

CASTOR BEAN

qiqayon
Ricinus communis

> *Then Jonah went out of the city*
> *and sat down east of the city.*
> *There he made himself a shelter and sat in its shade,*
> *waiting to see what would happen to the city.*
> *Then the Lord God provided a castor bean plant*
> *and made it to grow up over Jonah*
> *that it might shade his head*
> *and save him from his distress.*
> JONAH 4:5-7

This famous plant came up overnight and died the next day. Not so the debate among botanists and Bible scholars who have tried to identify which kind of plant it was. Most think it was probably the castor bean plant because its habits and appearance fit the verse so well. It is a tall shrub with umbrellalike leaves that grows quickly and to the size of a small tree.

Its fruit is a capsule covered with soft prickles and containing three large seeds. When removed from the seeds, castor oil is used in medicine and as an engine lubricant. The plant is also grown as an ornamental, even though its seeds are poisonous if eaten directly.

32

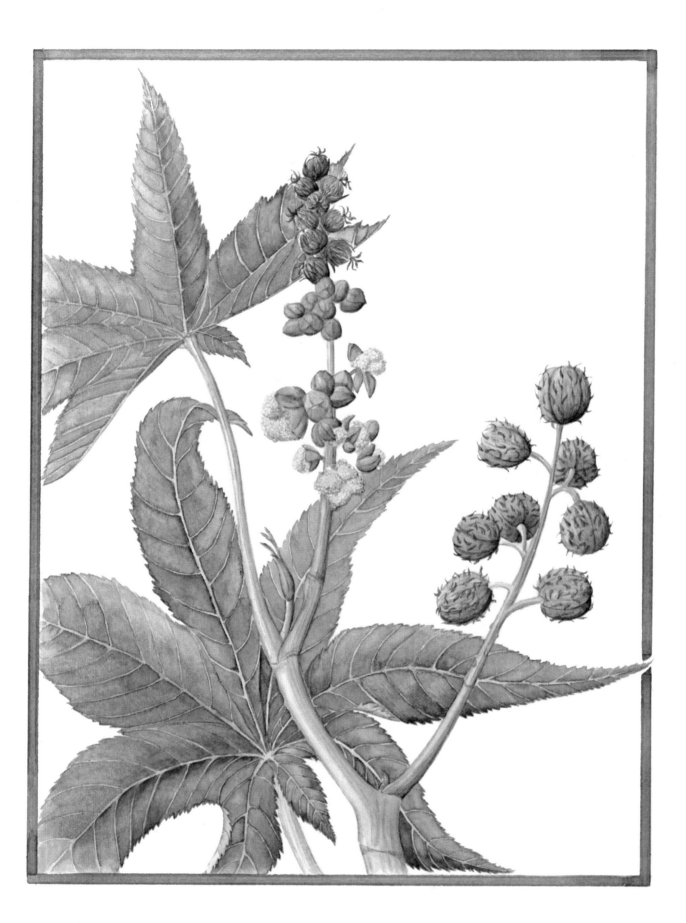

CYPRESS

te'ashur
Cupressus sempervirens horizontalis

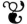 *They made your oars of oaks from Bashan;*
they made your deck strong with cypress
from the coasts of Cyprus.
EZEKIEL 27:6

A tall evergreen with scalelike leaves, this cypress is native to the eastern Mediterranean. Its wood is hard and strong and was used to make boats as well as buildings. Although Bible students argue about the translation of *te'ashur*, many authorities believe it is the cypress because the area where this tree grew and the qualities of its timber are appropriate to the verses in which it is mentioned.

Cypress still grows in the wild in some forested parts of Israel, but these stands are much rarer now than in the past. It is often planted there as an ornamental tree.

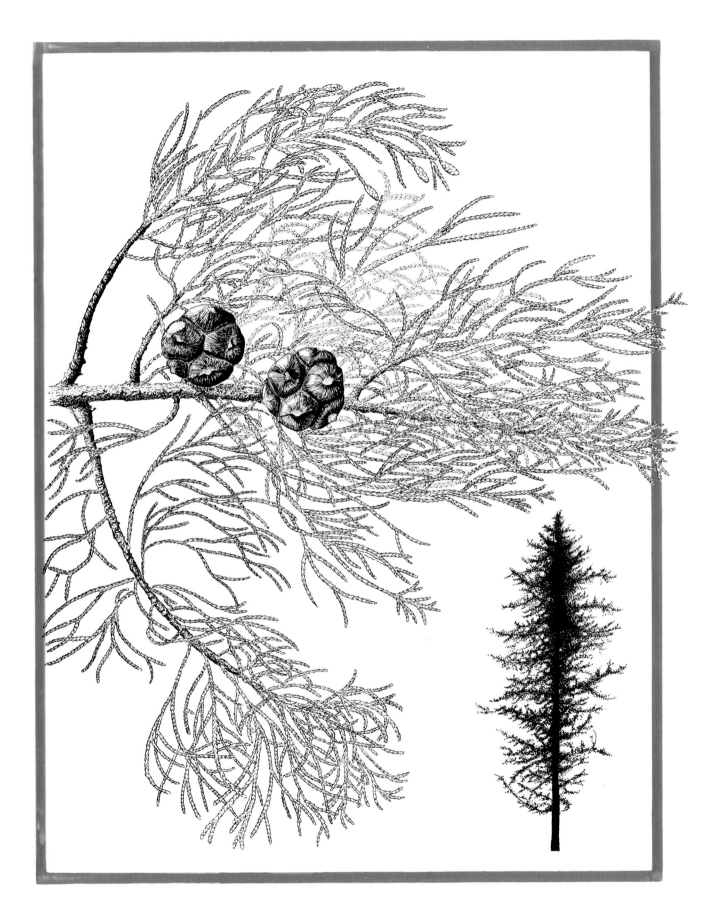

GRAPE VINE

gephen
Vitis vinifera

℘ *You removed a vine from Egypt;*
you drove out the nations and planted it.
PSALMS 80:9 (8)

Bread and wine hold a central place in the religious rituals of the Western world, and the culture of grapes may be as ancient as the growing of grains. When the floods leave the earth and Noah makes his vineyard (Genesis 9:20), the grape becomes the first plant whose cultivation is mentioned in the Bible. Grapes were eaten as fresh fruit, dried for raisins, and made into wine and vinegar.

The plant and its fruits are mentioned throughout the Bible. In the verse from Psalms, the vine becomes a symbol for the Jewish people themselves; elsewhere it signifies peace and prosperity.

36

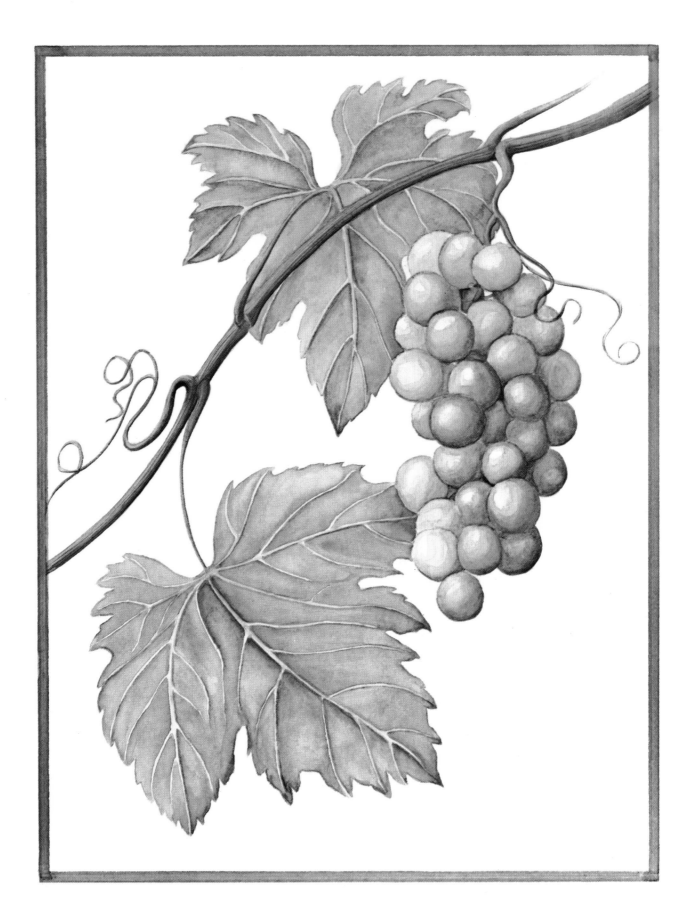

SYCOMORE

shiqmah
Ficus sycomorus

Then Amos replied,
saying to Amaziah, "I am no prophet,
nor am I of the group of prophets;
rather am I a herdsman
and a piercer of sycomore figs."
AMOS 7:14

The biblical sycomore is not related to the North American syca-more tree (*Platanus occidentalis*) but is one of the two thousand different species of fig plants. Of them, only the common fig (*Ficus carica*) and the sycomore are grown for fruit.

The sycomore fig becomes a massive tree, thirty feet tall or more, with a heavy trunk and wide-spreading branches. Clusters of fruit are crowded on twigs that grow from the trunk and older branches. Amos speaks of one of the tasks that must be done before the harvest of the sycomore figs: the growers make a small hole in each fruit to speed the ripening.

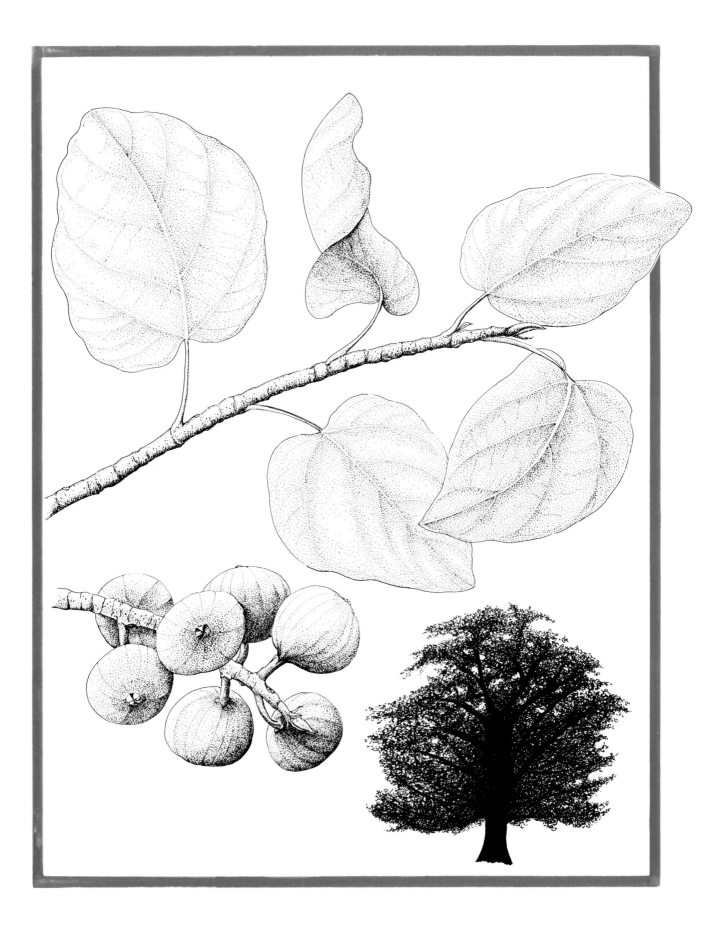

CAPER

abiyyonah
Capparis spinosa

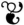 *...and the caper fruit shall fail;*
for man goes to his grave,
and the mourners go about the streets.
ECCLESIASTES 12:5

The caper plant is a low, sprawling shrub that can grow in difficult places—on old walls and in dry, rocky valleys. Each large white flower blooms for just a single night. The green buds are gathered to be pickled and served as a flavoring for meat.

Eating the buds and young fruits was thought to stimulate appetite and the sense of taste. The verse speaks of old age as a time when the caper plant no longer has this effect.

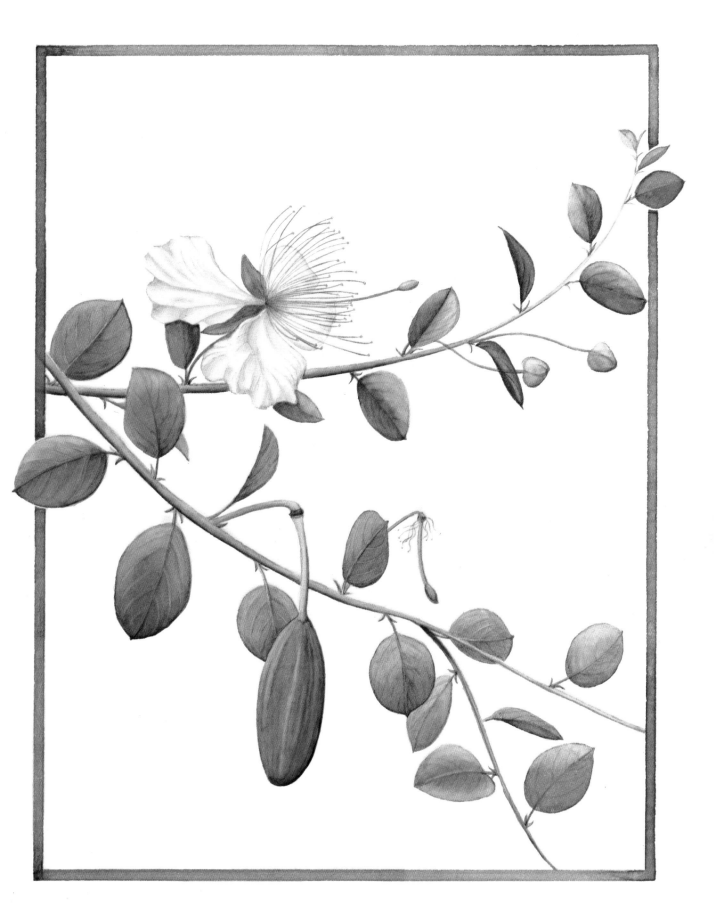

DATE PALM

tamar
Phoenix dactylifera

🔖 *The righteous shall flourish like a palm tree....*
They shall still be vigorous in old age,
full of sap and luxuriant leaves.
PSALMS 92:13, 15 (12, 14)

A date palm growing by itself will not produce fruit, because the flowers that develop into fruits (female) and the flowers that make pollen (male) grow on separate trees. A cluster of female flowers is shown here. The brown sheath that covered the growing cluster has split open, and now the flowers are exposed. They are very small, arranged along twiggy stalks.

After it is pollinated, each flower develops into a single date fruit. The fruits from one of these clusters weigh from ten to forty pounds, and eight to twelve such clusters may be produced by a healthy tree. Date palms live and continue to bear fruit for over one hundred years.

42

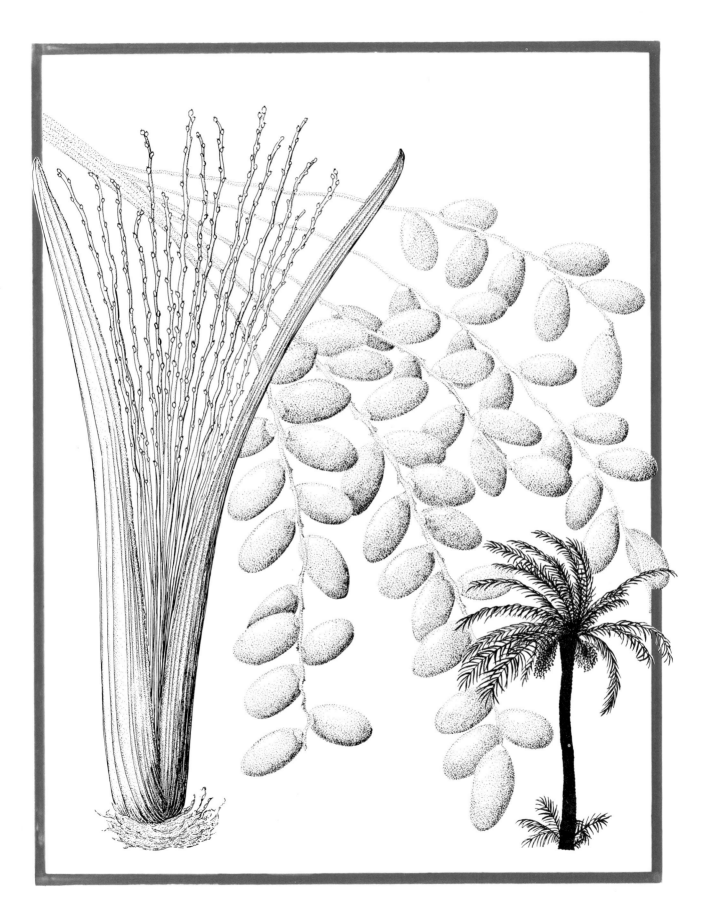

OIL TREE (ALEPPO PINE)

'ets shemen

Pinus halepensis

 And that they should announce and proclaim
throughout all their cities and in Jerusalem,
saying, "Go out to the hills and fetch branches
of the olive, the oil tree, the myrtle, and the palm,
and other dense branches, to make booths,
as it has been written."
NEHEMIAH 8:15

The Aleppo pine grows throughout the Mediterranean lands, especially along the coasts. In Israel, it is a common tree of natural forests on the hills and mountains. Since it grows quickly, this pine tree is also widely planted in modern Israel as a timber tree. Its resinous sap ("oil") has been used since ancient times to make turpentine and tar.

Although biblical students disagree about what plant is meant by the words *oil tree*, the identification with Aleppo pine seems the most probable one.

44

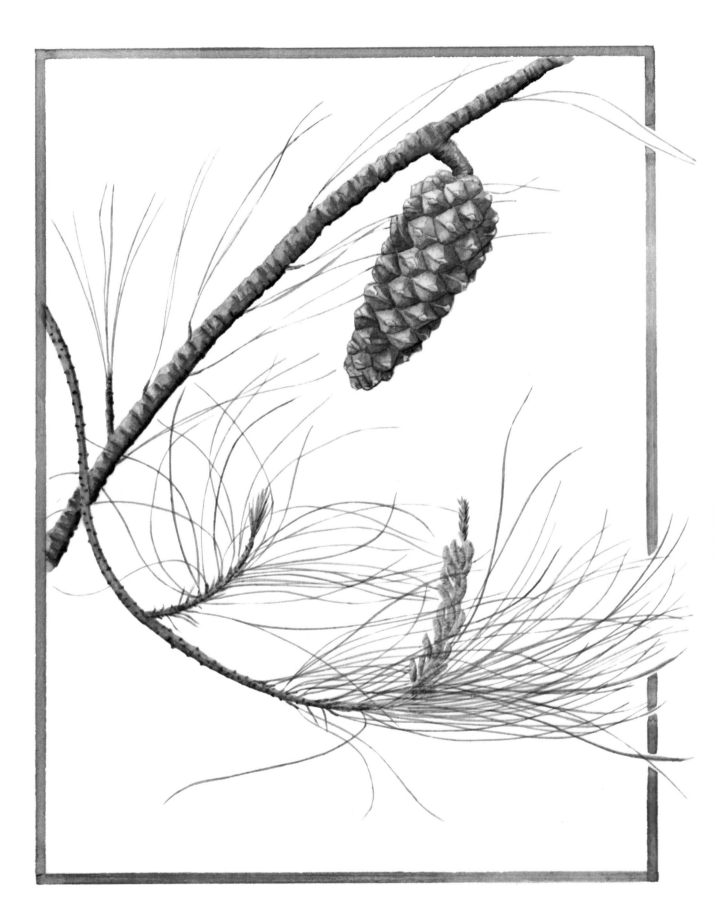

POPLAR

'arabah
Populus euphratica

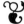 *By the rivers of Babylon,*
there we sat, there we wept,
in remembering Zion.
On the poplars there
we hung up our harps.
PSALMS 137:1-2

Willow trees and poplars are members of the same plant family, the *Salicaceae*. Students of Bible plants say that the same Hebrew word is used in different places in the Bible for both of these kinds of trees. This passage from Psalms refers to the Euphrates poplar, which is common along river banks in the ancient land of Babylon.

The leaves of this poplar have two different shapes. One is broad; the other is long and narrow and looks very much like a typical willow leaf.

46

ABOUT THE AUTHOR-ILLUSTRATOR

Carol Lerner was born and raised in Chicago, receiving her undergraduate education and an advanced degree in history from the University of Chicago. She has also studied ornithology, botany, and botanical illustration at the Morton Arboretum in Lisle, Illinois. Mrs. Lerner has written and illustrated a number of books on botanical subjects, including the much-praised *Seasons of the Tallgrass Prairie,* which was named an ALA Notable Book for 1980.

The author-illustrator lives in Chicago with her husband and has two sons in college.